PROEM

PROEM

A Poetry Collection

MEGAN KIRKPATRICK

Megan Kirkpatrick

For my parents and loved ones and their
endless support, the midnights and summer
afternoons that brought me these poems, and
Little Megan who always believed in me.

Contents

CHAPTER 2- LESSONS LEARNED

CHAPTER 3- NOSTALGIA

CHAPTER 4- BEATRICE

I

THE BEATRICE DRAFTS

FOREWORD

I began writing poetry in March of 2019 on a whim. All throughout elementary and middle school, I hated poetry. This was largely due, I am sure, to my limited exposure towards the art form. I can't pinpoint exactly when my mindset shifted, but I know it stemmed from necessity. One cloudy afternoon in March, my first real poem wrote itself in my head and compelled me to put it onto paper. It was all downhill from there— in the best possible way.

In June of the same year, I started my poetry Instagram account (now @meganmadewords) to give my favorite pieces a place to belong, and myself a community with which to share them. While I confess that this endeavor has yet to reach the level of success for which I had originally hoped, it kept me writing and it kept me reading day in and day out. It's been more than two years since I began this journey, and I've yet to go a single week without sitting down to write. I can't even begin to count the number of times poetry has saved me on the hard days and added joy to the best ones. I wholeheartedly believe that God knew how much I would need it, and deeply embedded my constant need to create and remember deep within my heart.

Proem Is more or less the highlight reel of my poetry up to this point in life, June 20, 2021 as I write these words. It is all my best and worst memories, all the living that now stands behind me with the rest of history, and a beautiful display of how far I've come. The first three chapters, *For the Poets, Lessons Learned,* and *Nostalgia* are non-chronological assortments of my favorite poems I've written and saved for the book that I hoped would one day come to be— the book you are currently holding. Very few of the words within these pages have been previously shared with the world, and it is my honor to finally share them with you.

Beatrice, however, has been my muse for as long as I can remember, long before I was ever a poet. In early 2020, I brought her to life on paper for the first time as a series of nine "Beatrice poems," which were originally shared via Instagram. Those nine poems are included at the end of this book as *The Beatrice Drafts,* very minimally edited from their original forms despite my intense desires to insert better metaphors during the formatting process. :)

I came back to the concept of Beatrice in the summer of 2020 when I wrote her into a full-length novella. I then announced this draft as a publication in the works a little too prematurely, to say the least. In returning to that manuscript months later, I found its edited form to be far too short for a solo publication. Thus, a much-condensed form

of this novella is included as the fourth chapter of *Proem*, the chapter for which I am perhaps the most excited.

I hope you enjoy these words half as much as I have enjoyed creating them. I hope my honesty shines through, and how Jesus has carried me all the way shines through even brighter. I hope that, of all the poems between these two covers, even just one of them grabs at your heart or comes back to hold your hand later on in life when you need it. I hope you keep hoping, keep noticing the little moments that mean everything, keep living like you only have one shot at this life because, the reality is, you do.

Much Love,
Megan

CHAPTER 1- FOR THE POETS

A Letter to the Chronic Feelers

You must fear the water. To be a poet is to be drowning in both the beauty and the pain of living and to find an alternative form of breathing, like I did. Like this.

As you learn though, and often even after your sea legs have firmly attached themselves to your hip sockets, the waves all still seem evil-eyed and poised for attack.

It's daunting, really, to think of all the writers who have lived before you and that everything you have to say has probably already been said.

You have only the same 26 letters as all your predecessors and to spend hours into the night rearranging and remixing them, hoping to come up with something new, seems futile.

I counter with the question, though, how many times exactly have we reproduced the Mona Lisa? Why do people still cry in chapels when all that's left to feel are recycled feelings someone before us has already felt?

There is so much of science we know and even more that we don't and I have to believe literature to be the same. Actually, I choose to believe literature to be the same.

Poetry seemed to me a cryptic, high-class sort of knowledge for philosophers in musty libraries. I've yet to determine precisely what compelled me, but I dove in and realized much of it to be, in fact, the opposite. It's a tangled web of middle schoolers and great-grandparents and everyone in between who's tasted the power to be wielded when armed with blank paper and a pen. We are photographers with our minds, interpreters with our hands, and hurricanes within.

Poetry is a chaotic mess of feeling alive or heartbroken three days buried inside or anything really, just feeling and turning it into something beautiful by which someone else might feel less alone.

As for you, there are poems seething behind your gritted teeth, I am sure of it.

Fear the water first,
Dive in second,
Learn how not to drown third.

We are all poets if we want to be, if we need to be.

I Have So Many Things to Say

I have so many things to say.
I have them delicately packed away
In labeled boxes, spilling from every cozy cobweb corner
Of my attic.
I should be plastering eviction notices
Over every chink in my wood log walls.
I don't always do as I should.
I know all my half-finished poems by name,
Bring them warm milk before bed,
Tuck them into the folds
Of my favorite quilts,
Waive their rent on a regular basis,
Let them stay while I
Stay silent.

Swords & Honesty

What about the hard things
That didn't feel like poetry,
The words still stuck
In the back of your mind
Or your throat
Or your mouth
Where they roll at the weight of your muted tongue
As you weigh the cause and effect
Of finally deciding to spit them out?
It never matters how long you think about it.
You're afraid of the earthquakes they might start
When they come flying from between your lips like a
thousand swords
And hit the floor
Hard.
So you hide them away again,
Just like always.
Fifth amendment, jagged edges in your flesh,
You tell yourself you're just keeping the world safe.
You forget that's never been what it needed.

Covenant

This is my covenant
To drop everything when a poem comes flying at me
Kamikaze
No regard for my toes in the aftermath
Of preventing a crash-and-burn little war.

This is my covenant
To keep my arms open,
Catch the poem and prune it,
Stake it, twist it, polish the frayed, sunburnt ends
While it's still flying at me full-force.

This is my covenant
To remain wholly and eternally honored
Over being selected as its target.

This is my covenant
Never to flinch.

To All the Poets Who Are Brave Enough Not to Hide Behind Metaphors:

Keep letting the dragons and the doves
Crawl out of your throat hand in hand.
Speak your heart exactly as it is.
Don't be afraid to fall and break hard
And to love even harder.
Writing
Is the noblest pursuit that will ever befall you.
Just remember:
It's bullets that kill,
Not taking off your armor.

We Rise Again

Last night
I didn't break
Because that's too cliché.
This morning
The sun didn't rise,
The day wasn't new,
And I wasn't either because
That's too cliché too.
So instead,
I say that last night,
I was a tree alone in the middle of the prairie.
The ground was tired of holding me.
The sky was swelling and swelling and swelling
And only thinking of itself
Even though I'd rather believe
That it just didn't see me.
The torrents of bullets broke loose and suddenly,
The weary, unsteady ground
Became a battlefield.
The dirt flicked me out of its grasp,
The wind laid me down on my side,

And then everything stopped
As if the only purpose of a storm
Is to defeat lonely, trying things.
I was very much a trying thing.
I kept growing,
My every inch closer to escaping the atmosphere
A *rebellion.*
My every branch and new leaf
Twisting together in beautiful symphony of living,
Screaming at the storm
That it didn't win.
But really,
All I mean is that
When we break,
We rise again.

I Can't Write...

I CAN'T WRITE IN STRAIGHT LINES.
I write in s-swerves
Down the North *and* South lanes of the highway,
One hand on the steering wheel,
The other clutching probability by the neck.

I CAN'T WRITE SLOWLY.
I write like an escaping convict
Holding stories that aren't my own.
I scribble them on paper
To throw back at the world
Before I'm found in possession of property
That never belonged to me.

I CAN'T WRITE LEISURELY.
If I were to stop,
I would either explode or implode.
Neither would be pretty.
I'd rather go down
In a blaze of contradictions and repetitions
Than slowly slipping from sanity in silence.

Nights like These

On nights like these,
I sink to my knees in defeat.
I lay flat on the floor
With a heart so heavy
It teeters on the verge of falling out of my chest
And scientifically,
The closer I am to the floor when it does,
The smaller the probability
Of its breaking beyond repair.

On nights like these,
Whole oceans well up behind my eyes
But the tide of tragedy
Just isn't strong enough to pull them loose
And my consequently waterlogged mind
Can barely form my state of being
Into a single coherent sentence.
This poem is my best attempt.

On nights like these,
I push my fingers to record speeds

To keep up with my panicked, racing mind.
I disrespectfully disregard all pleasantries
To both myself and the forgivingly blank slate of a page.
I force as much pressure as I can
Through the tip of my ballpoint pen
Before it crushes anything too vital inside me,
Swallow as much of my favorite poetry
As I can keep down.

On nights like these,
I write through the dark hours of existence.
The sun starts to rise and I don't see it.
The birds start to sing and I don't hear them.
The frost starts to melt.
I don't feel the thawing,
But I've made it.
Again.

Solid Stone to Curtain Call

Life has become an intermission between poems,
Like I live on eggshells
And write on solid lapses of stone.
I run through fire,
Drink the sky by the barrel full to cool down,
Always make it back in time for the next act.
The curtain falls,
I cry my way through curtain call,
Dance off cliffs and spin down waterfalls
Holding my breath in between shows
And when I take the stage again,
I exhale all of it.
The show goes on
Because it simply must.

Introductions// Burn

I was born on a sunny day in June.
All heart on my sleeve when I try to hold back the river,
Foot in my mouth when I try to speak,
Butterflies in my stomach when I try to spread my wings,
Everything or absolutely nothing
By way of loving.
Chronic wanderlust,
Renegade daydreams,
Sweet with a touch of sour in the aftertaste
That I just can't filter out;
And I guess I haven't changed much.
My summer afternoons
Are full of black coffee on the front porch.
Maybe my sour turned bitter
And now I crave it.
·It tastes like the earth and I remember
From where I came,
The foot in my mouth,
The tsunami floating around my head.
I'm finding little ways to release it
Like this one—

Unsteady and highly dangerous.
It's a gas leak and I'm bound
To go up in flames
Someday.
I'm not afraid to burn
But I hope
You never have to watch me.

I Want to Live in a World Where:

I want to live in a world where
I can tell the people who show up in my dreams every night
That they show up in my dreams every night,
Where they won't side-eye me
Like I'm a stalker.
Where everyone tells me
When I show up in their dreams, too.
Where we don't have to dissect it
Down to a science.
Where I can take you
And rainstorms
And death
All at face value,
Know they're all footnotes
In this eighth symphony.

Potentiality

I could tell you about
The voice you only bring
Halfway into the light,
The fire you don't know
Blazes down your veins,
The bones you don't know
Aren't so brittle,
And the wings that ache
To be stretched.
I could try convincing you
To use them all,
To stand up straight and tall
For your story, shaking and ready
To be let loose
But none of that will kill your fear.
So instead,
You should know that tomorrow will accept you
If you arrive shaking in your boots.
Every beautiful thing you have to say
Will be louder than every mistake.
If rules are made to be broken,

So is fear.
When I was two years old,
My momma says,
I found my voice.
I used to stand front and center
In our tiny apartment kitchen
And scream for all my even tinier self was worth
So I would never forget
How to use the most powerful weapon
I'll ever wield.
I'm not two year old Megan
In an apartment kitchen anymore,
But I still scream
In poems.
I still remember
Never to let myself forget what I sound like.

What I Got for Loving with Everything in Me:

Goodbyes.
Goodbyes like ceramic plates and cement.
The cement always wins and
Something in the sound the plates make when they shatter
Tries to convince me
That I was the one who dropped them
From the top of the stairs.
Something in the way I feel
When I'm cleaning up the broken pieces
Feels the same
As closing the door on something I loved,
Something I was sure would stay,
And turning to face the empty walls
I'm supposed to call 'home.'

Dehydration.
The moment I close the door,
Face the empty walls,
And fail to force the feeling of belonging

Into a box that isn't,
Every drop of life is siphoned
Out of my still-beating heart,
Leaving it pounding dry
Like the hollow thud of a kick drum,
Drying up all my seawater rivers like summer in the desert,
Leaving the stinging salt behind,
Never forgetting to knock my inkwell over
On the way out.

Memories.
Memories like beautiful wrecking balls
And mirror glass knives.
Some pretty things hurt too much to look at,
Like the sun.

Absolutely no regrets.
Everything that breaks on its way out the door
Comes back around
To rebuild the wreckage of rubble it left in its wake.
There is no such concept
As loving hard enough.
The loudest thing I've learned from living
Is that wishing you'd loved harder when you had the chance
Is the only fear worth carrying.

CHAPTER 2- LESSONS LEARNED

How I'm Learning to Love All of Living:

I'm putting the good and the bad
In my mouth together.
I'm chewing the shards of glass
With the coffee and honey,
Swallowing it all
Just the same.
I'm breathing in
The smoke and the oxygen,
Keeping all my cards
In the same pocket.
If I lose,
I lose it all.
I'm sleeping under the stars
And under the sun,
Learning this is how it should've been
All along.

The Fruit, the Freedom, and Me

I can hear the snake in the tree.
I know how this went down last time,
But I'm weak and I know how to listen to
Exactly what I want to listen to.
It doesn't have to end like this
It doesn't have to end like this
It doesn't have to end like this...
But that doesn't mean it won't.
Some people were born to break cycles.
I don't know that I was one of them.
In fact,
Most days I think I wasn't.
In fact,
Most days I wonder
If fruit tastes sweeter than freedom.
In fact,
Most days I forget how sweet living is
Even when I'm tasting it.
So easily I forget the white horse

And *Faithful and True,*
Now this is through.
The once and for all,
The end of it all,
The beginning of everything.
Instead, I spend my days
Reminding myself of all the times I lost,
All the times I fell
And I bled and I died.
I think I usually cut out the part
Where I came back to life
Even though it happens every time
Gosh, I have such a one-track mind.
Forget the fruit, girl.
Remember the freedom.

I Think I Am the Flowers

There's a bouquet of dried flowers on the floor.
They disintegrate a little more
Every time I step on them
I cringe
And they've been a metaphor
For as long as they've been there
I've been avoiding it.
Sometimes I find reality
More terrifying than others and
I THINK I AM THE FLOWERS.
I watch otherwise dainty feet walk all over me.
I stay anyways,
Watching pieces of me crumble all over the hardwood.
I don't attempt to put them back together.
I say I find them oddly pretty in their broken state.
I keep the truth to myself—
I'm just not strong enough
To fix anything.
Either that, or I'm just too foolishly nostalgic
To undo something someone else did,
Like break me.

AND IF THAT"S NOT ENOUGH OF A METAPHOR:
Wildflowers wither with the welcoming of winter
And this one, I'm finding,
Is no different

My Head & My Heart

Somewhere along the way, I'm realizing,
'Surviving' became an acceptable state of being.
I only almost cried three times this morning
And I call it a victory.
Besides that,
Never once did I feel
That the walls were plotting against me,
That for some unforeseen reason
The doorway would be out of reach
When I needed it most,
That I wouldn't be alright.
Times like these make me wonder
Is it my head or my heart that guides me?
I can't hide that my heart is fragile
But in a wasteland such as this one,
Something has to keep me soft
And I wonder how much
I should trust my head anymore...
All this time has there been
A traitor within
And has it been me?

Am I safe in myself,
In these bones that maybe
I never knew so well.
If I'm lost in the woods,
No rescue team is pursuing me.
I never expected them anyways.
But even still,
Every new moon, no-sun road
All the way home,
I'll be scanning the sky for searchlights
Holding my own hand.

Home

These bones are not a frame for nothing.
They are heavy and steady
Under the weight of my mercy-laden being—
Creaking when the wind blows,
Inviting the sun in with open arms.
These bones are good at holding hands.
They're still holding the one
Of the dead weight hiding in my shadow.
I just want the courage
To break it and walk away.
I just want a Megan
Who's done breaking,
A Megan who wakes up in the morning,
Burns whole forests down,
And still calls waking up the victory.
I want a Megan
Who unpacks her bags
And stays awhile,
Who lets these bones be home again.

In Case I Didn't Seem Angry:

Some days I smile so flawlessly
The mirror thinks I've never known
What it means to cry
And maybe I haven't.
Maybe the tears that have held me
When nothing else could
Were crystal condolences,
Grocery store roses
Wrapped in wrung-out sympathy cards.
Maybe sobbing in the shower
Is a metaphor for screaming in the rain
Because the sky is so big and so heartless
And we take it to mean
She can't hold our anger against us.
Maybe my cellar is teeming
With bottles of silent storm clouds.
Maybe the mirror takes for granted
They'll be silent forever.
I walk lightly and I hate

Breaking things; even still—
Accidents happen sometimes.

A Confession

There are days I loathe hope for existing.
There are days I pretend to believe
I'd rather accept defeat
Like I have no regrets
And no brakes to stop me
Even if I did.
Eleven weeks ago,
I sat in this same room
In my same yellow shoes
Praying the same prayer,
Started crying in a silent crowd of people,
Didn't try to split the cycle.
Hard Love played on repeat.
I was afraid of folding
If it ended.
In that moment,
Hope cut deeper than grief ever could.
Black holes were all stars once
Until they gave up on shining,
Imploded,
Masked their faces, and pulled

An innocent plot of atmosphere with them.
If hope is a dying star these days,
I've always had a tendency
Towards planting my feet
On precarious culminations, and well...
Eleven weeks later,
I'm sitting in the same room
In my same yellow shoes.
Hard Love stopped playing.
I kept hoping.
It's raining outside and the light
Isn't pouring in like last week,
But there's light enough in the fact
That a new day has arrived
In full display of glory.
If she can do it, so can I.
One breath at a time.

Forever & the Like

Trying is a synonym
For dying.
We climb
Until our fingertips crack open,
Begging us to surrender
In silent rivers of red.
We fall forgetting
The ropes attached,
Hang from our ankles
Waiting to be saved,
Waiting to be taken
Back to the ground,
Rise again because
We're ever-hopeful and ever-striving.
Because the harder the climb,
The stronger the lock
Of sight lines and sunsets
Only to end in a crash-and-burn nosedive
When our engines give out.
Nothing lasts.
We'll all die someday,

But as long as I'm here,
I solemnly swear to ache after forever.
Every fiber of me screams
That surely my bones weren't created
To reach and then wither.
These eyes were never polished
To see the light for a little while
And then never again.
This heart could not have been crafted
To heave and shrink and love
Terminating existence.
No, I've always known
Forever is surely waiting for me.

For a Friend Who Never Outshines Anyone's Sun

I haven't seen the moon in awhile.
I hope she's doing ok.

Is it just me,
Or does she seem smaller?
I can't decide if she shrinks
At the shoulders or the knees,
But while we're on the subject,
The last smile I saw
Was more of a crater.
I know
She's been spinning forever, but
I think she's getting dizzy now.
I think she's looking
For something with which to collide and
Collateral damage is the objective.

What shall happen to the earth
When she shatters?

Homecoming

I was the center of the earth,
My heart the origin of all gravity,
Pulling every layer
Heavier on top of me,
Forgetting that my lungs are not steel cages,
My lungs are paper bags
Filled with fine china breaths,
Twelve at a time.
Twelve china cups,
Twelve gulps of poems.
I drank them as slowly as I could,
Holding each one with such desperation
Every handle broke off.
Every exhale was a verse,
A drop,
A shatter,
An unresolved letter.
The last two were goodbyes,
Stretched thin,
Slower.
My paper bag lungs gave out.

My hand dropped the last empty cup,
Splitting its saucer clean in half
With a snap of defiance.
As I sunk below the surface,
The gravity in my ribcage an ever-faithful catalyst,
Life became a hallway
In my rear view mirror.
I turned the key in a new lock
For the last time.
Home wrapped itself around my shoulders
Like a blanket.
Gravity left me alone.

To: College Megan

An hour at a time
Turns into a day at a time
And then a week at a time.
Before you know it,
You've made it
Another month,
Another year
And when you feel
Like all your back tires can do
Is spin in the gravel and the mud,
Like the hills stand silent
In the thick summer air
Instead of rising and falling
With your passing distance,
Give yourself time
As if you have it in abundance.
Don't close your eyes anymore.
Feel the acid rain.
Feel your incredible capacity
For reconstruction.
Pick lots of wildflowers.

Take lots of pictures.
Remember where your strength comes from
Before you reach the foot of the mountain.
All too soon, these days
Will be memories
Clutched in your trembling palms.
And as unsteady as the road may be,
Solid ground is no more deserving
Of holding your anchor.

Forgiveness

I kneel in the corner
Of my ignorance every morning to pray.
All that spills from my mouth
Are apologies these days and I
Have everything, and nothing,
To be congruently remorseful over.
I've never been a worse daughter
Than the one who hides the sun
From my shadow.
I'm head-over-heels infatuated
With the beautiful idea of laying forgiveness
In my own lap,
Plagued with a chronic stumble
In the follow-through.

The Loudspeaker Says
"Cleanup in Aisle Three"

I owe too many people
Too many apologies
For plucking daisy petals
Every other day,
Crying when
The curtains close on *loves me not,*
Crying when
Words fall helplessly to the floor,
Lay there like broken jelly jars
In a grocery store
Bleeding all over clean tile.

For: My Mom

It's hardest to write
About the people you know best,
But if I were to try,
I would say that God
Hit copy + paste when He made me.
I would say that I
Have yet to live up to it.
I would say that my Mom
Has terrible rhythm,
But everything she does
Is a beautiful melody of grace.
She's the grease to our squeaky wheels
And if my daddy's the mast,
She's all of the rigging
All of the time.
If he's the foundation,
She's the ground
Who never forgets
To leave me the extra coffee
And wash the dishes that I left
And teach me

And teach me
And teach me
And these days at home
Are a landmine of gold
I so easily take for granted,
But I try
To soak up her every word
For when I move away
And she's just a phone call away.
Phone calls just won't be the same.

CHAPTER 3- NOSTALGIA

Shouldn't Be Mine

I stole this life
And I'm running with it;
This life with the family I got
And the family I chose
Who all love me like nothing else.

I try to fit them into words
Like summer flowers pressed between pages
To find in winter,
Dried but still
In perfect color
So I never forget a single word that passes through the air be-
tween us
While I have these days,
But I never can.

Words don't press like flowers;
Paragraphs squish into sentences
That crumple into misconstrued phrases like dust in my hands,
I'm just so afraid of forgetting how much I love this
That I try anyways.

For: My Dad

I remember leaving Broadway shows
In fancy clothes
For $1 ice cream cones
On the side of the road.
When it's daylight bright
Straight through midnight,
It's so easy to lose track of time
Like a missed flight
And time has no more mercy to give
Then we have for ourselves.
We ended up
Where a lack of forgiveness
Always seems to take one—
Greasy city bus seats,
Hopping guardrails,
Sprinting across 6-lane highways.
Racing curfew on someone else's time stamp
Is a losing game every Friday night.
On the morning train headed downtown
With the work commute crowd,
We played the blending-in game,

Too spellbound and otherwise oblivious
To notice the bird trail of gas station breakfast crumbs
Left in between cobblestones.
The sparrows never told,
I broke the facade
Gawking over ferry railings
And high rise balcony sides.
We always tried again
The next day
And the next day
We always lost again.
You were always right;
I can't live my life
Underneath armor that keeps me from running.
There's a breathless beauty in honesty.
I never see it so loudly
As when I'm with you.

Levity

The sun is setting
Whether I'm there or not.
The concrete landing strip
That is the road I've grown up on
Is set for my departure
And my wings are spread because
As the lion of our solar system pride
Slips behind the war-tarnished
Silver-lining foundation
Of the sky,
I am not here.
I am watching, teary-eyed,
Next to the clouds
Who never shame me for crying
(They know what it's like).
I am catching a glimpse
Across the still surface of the globe
Of someone
Watching the same sun set,
Maybe thinking about me, too.
We hold hands

From thousands of miles apart
And no,
Maybe I don't have time,
But her hand needs held
Because I might never see her again
And the sun waits for no one.
I'll be home before sunrise, I promise.

In Her Mind

In her mind, she's running
So fast it could be called flying.
It's probably just dark enough for streetlights,
But not quite for whispering with stars
While showering in moonlight,
Hair dripping the chill in the air down her back.

In her mind, the sun is setting
A thousand different ways
Like a song stuck in her head
That's intentionally been given no escape,
A song that's been welcomed to stay
Rent-free as long as it replays
Behind her glowing glass eyes.

In her mind, the mountains
Ask about her when she's gone,
Send their well-wishes.
All the tears ever cried into the ocean
Were the result of her absence.
And when deciding where to go next,

The sun takes her whereabouts
Into highest consideration.

City skylines stand painted
Just beyond the reach of her fingertips
Like something calls her
That isn't this
And she tries
Not to hate reality for it.

Untitled

The first ones...
The first ones loved me before I knew them,
But I loved them back eventually.
I was still Little Megan back then—
Little Megan who showed them
All her new shoes,
Ate picnic lunches in their front yard
(Even Little Megan wanted to taste leaving home),
And that's who they always loved,
Always knew.

I still remember the morning the ambulance came
(The first time).
I remember knowing exactly what happened
Before anyone told me
(I don't know how, but I did).
I remember the blissful ignorance
Of not knowing to dread what came next.
It was easier that time.

The second ones...

The second ones were here waiting
For still-little Megan
Like the pot of coffee they promised
When I turned fifteen.
I think they thought I'd forget.
I never did.
The royalty of this small town,
They travelled the world and
Brought back pieces to feed my daydreams,
Loved people like no one else I've ever known.

I still remember the morning the ambulance came
(The second time).
I remember knowing exactly what happened
Before anyone told me
(I don't know how, but I did).
I remember knowing
Exactly what to be afraid of this time;
The empty days
Of never crying,
Never understanding why.
I remember drinking coffee alone
On my fifteenth birthday,
Telling myself I was okay,
Believing the lie.

The third ones...
The third ones never knew
How much I needed them,
I don't think.
They've only ever known this Megan.
It's better that way.

Sometimes though,
I still get scared.
I still hold on white-knuckled and
Too hard.
I've only ever seen
The side of things like this that never lasts.
I love on anyways.
It helps that they love me back.
It helps that part of me believes
Things like this last sometimes.
It helps that I know
This one will.

Yellow (Vol. I)

I live for days like this;
Up here in the hills
Where the mountains tiptoed
Before they learned they could run.
The sky is blue most of the time
And it reminds me of Guatemala.
The rest of the time, the clouds try to hide it.
I don't think they like to see me cry.
The bugs in the cornfields hum
In live wire symphony.
The golden seas stretch for miles,
Butterflies find the tiniest pillars of light
And dance in them for hours.
I smile at the flowers.
They smile back.
What a day to be alive
And if yellow were ever to be
A moment in time,
It would be this one
Riding in the backseat
Down a dirt road,

Windows wide open,
Hair at the mercy of the breeze.
I whisper to the wind
"This must be what you feel like
All the time.
It must be nice."
She doesn't reply.
Yellow falls like rain
All over my shoulders
And I wish you could be here with me
Where summer skies
Float off into daydreams so easily...

Liberation

I'm the girl who only chases adventure
Until it becomes unfamiliar.
My voice still quivers
When I have to talk to strangers.
I sing in the shower
To deaden my own roar.
I bend over backwards for people
Who never give me a second thought
And I know I shouldn't.
It's about the most rebellious thing
I do on a regular basis,
If that says anything at all about me.
That's why I decided to start saying yes
To the wanderlust heart
Hiding underneath all the fear in my chest because
Letting it escape could be
The single most liberating experience
In all of existence
And I would never know.
I decided to start weaving myself
Into any fabric that might stretch me because

The seasons change more often than I do
And I don't take it as a compliment.
And nothing I've ever been afraid of
Has been worth it.
I used to keep my courage
Under a weighted blanket,
Keep it quiet
A little longer.
It's not working anymore.
It's not working and there's no lock on this door
And before,
This is where I would have made
Excuse after excuse about why
It would be so much easier
To set it free and live alone again
But this time,
I go.
I go with perfectionism on one sleeve,
My comfort zone on the other,
Hope I'll brush them off
Along the way.
And if they stay,
I'll live around them,
I'll live in spite of them,
In spite of me.
And just like that, I'm free.

Small Town Girls

I still remember the day
I asked you to promise
You'd never forget me.
It was selfish and unreasonable
And I'm sorry,
I was just afraid.
We were on the back porch swing.
The wind got caught up in your hair
All but perfectly
At the same time you turned to me
To say something I wish I could remember
About the thousands of miles of life
Folding out in front of you
And I think I always knew
You'd never be the one to stay.
We were small town girls,
Born and raised under the clouds
Like we were destined to be tasked
With nothing but getting out.
I hated that you learned
To hate being stuck before I did.

I was just too blind to see
That it would hit me,
Wreck me,
And we'd be
Victims of renegadeism together.
When I made you promise
To come back for me,
I never would've guessed
I wouldn't be here.
Promises aren't meant for breaking, I know,
But run the world left to right
And back again.
If I'm not running next to you,
Our paths will cross again,
I have no doubt.
And since time is relative,
It won't be long.

On Falling Asleep in the Backseat of my Dad's F150:

We drive the lifeline
To both my parents' hometowns in the dark.
Darkness magnifies nostalgia
Like morning light
And I sit as quietly as possible
In the backseat,
Catching less than enough scraps
Of reminiscent conversations
And shooting stars.
I put them both in my pocket
Even though they neither one
Stay until morning.
The sky is whole and vulnerable in front of us.
I feel invincible.
I wallow in memories that aren't my own,
Taking every brick road,
Looking in on small towns

From the outside.
They're all the same in the way
Someone hit pause
A handful of decades ago
And hid the remote.
My parents show me the streets
They used to know by heart.
All they say
Is how much it's all changed,
How much they've changed.
I catch another shooting star
And don't ask it to stay,
Pull my daddy's letterman tighter
Around my shoulders,
Fall asleep on the crest
Of another dying moment
In the backseat.

20/20

It was a quiet sweet sixteen,
Drinking milkshakes through paper straws,
Wrecking my skateboard and
Ruining both knees.
Over time I guess it became that I couldn't sleep
Without a notebook next to me
And sometimes I wonder
If I was really getting older or not.
Daydreams became my reprieve,
20-minute car rides were road trips,
And I never strayed that far.
Maybe because crossing state lines
Felt rebellious.
Maybe because I panicked
In the driver's seat.
That's what travel documentaries
Are for, I guess;
Missing airport terminals,
Summers spent alone at desks
In third-story bedrooms,
Painting loud walls quieter, and

Framing windows in threadbare linen
To replace the iron curtains
They used to carry.
I have nothing more to hide.
I lived the year alone
And in shadows.
It only made me realize
We're all the same, really.
Poetry made me honest,
Typewriters screamed my secrets,
Now I'm free.

She Told Me Wild Horses Sneeze Fairy Dust

Everything reminds me
Of summer lunches on the balcony
After long drives,
Sleeping priceless afternoons away
In the hammock chair hanging
Next to the driveway,
Empty Fresca cans,
Firing pizzas in the oven out back,
Rescuing tree frogs from inside the grill.
Everything smelled like the ocean.
The outdoor shower
Soaked the sea breeze into my skin.
The shelves were covered in pottery,
The windows in stained glass—
Breakable things, to smile back at the hurricanes.
The best part of the kitchen, though,
Was the wooden spoon in the honey jar
Throwing gold threads over Nutella toast in the mornings.
The walls of the house that stands

At 107 Ocean Oaks Drive
Hold the better half of my best years
And no one will ever love them like I did,
Like I still do.

Juniper

Maybe 16 couldn't leave me alone
Unless it left me grappling between the walls
Of a heartbreak chasm.

Maybe that's why I had you;
My best week of quarantine summer
Clomping through the kitchen into my arms—
Always into my arms.
The cause and effect of my 5:45 a.m.'s
Only to fall back asleep together
On the blue snowflake blanket
And the hardwood floor.
None of it was cold when you were next to me,
Sitting on the front porch while it rained,
Racing no one to get the mail when it stopped.
You were afraid of my typewriter,
Chewed the corner of my favorite notebook,
Stole my every thought and waking second
And they say love is blind, but
I swear I wasn't;
I could see plenty clear enough

To tie fate from my pinky finger
To your pinky toe,
A bow on each end
And strings like that don't break.

Someday if my heart un-breaks
And sixteen comes back to haunt me,
I'll let it as long as
I have you back.

Yellow (Vol. II)

I'm back again.
The golden fields
Went south for winter.
The tired clouds are still trying
To mask the blue of the sky and
Their kindness warms my heart
Against the thoughtless, bitter wind
But the melody to which
The ground pushes and pulls against gravity
Still reminds me of Guatemala.
I still cry, but
I smile picturing the flowers
Breaking through the snow
To catch a passing glimpse of your face
If you could be here.
The sky could be the same perfect blue
And the clouds could rest
Knowing my heart was done breaking.

I'm Still Stuck on That Ski Lift in New York

The night pink peeked over the clouds
Halfway through the afternoon
Wondering if anyone would notice
Her turning in early for the day.
No matter how hard
She tries to hide,
She's always shining somewhere
And I forgot that
We don't think about
All that's lost
Anymore.

I lost my mom halfway down the slope
So I got back on the lift
Alone.
It was blue and orange;
Orange from the rust.
I think I was only supposed to see the blue but
I saw the whole picture that night.

I saw me collapsing like an avalanche
Into the cold metal,
Trying to hide,
Always having something to shine for.

And the lift creaks
As it swings back and forth.
I'm riding the pendulum of time,
Always chasing me.
And the wind blows cold.
And the sky smiles back
With mercifully rosy cheeks.

Next Year's Hindsight

Ah, baby girl
Has her heart on her sleeve again,
Getting in the way of
Holding these moments in layaway
For when she's older and
Time can pay her dues and
She can take them home
Really belonging to her.
Their eyes haven't even opened yet and
She's about to close hers
Sleeping at the wheel,
Slipping out of hugs,
Regretting all the pictures
She never took.
These half-open arms
Are half-hers and it's only because
She thinks it'll hurt less that way
To close the door next fall.
Next fall,
All of this will peel
Off the inside of her perfect like old wallpaper.

They say you don't know what you have
Until it's gone
And she sure doesn't.
She knows she doesn't.

March 3rd

I woke up in the night
But the moon was gorgeous
And begging to be seen
So I didn't mind.
I slept to soft furnace rumbles
Like distant thunder,
Kept the lights dim.
The sleepy sun shyly spun in
Through the glass block window in the ceiling.
I never have to worry;
She always finds me.
Today is March 3 and I
Have traded time zones with the owls,
Blowing kisses goodbye
Under the surface of a world
Waking up for the first time.
A Christmas tree stands at attention
In the neighbor's front picture window
And did I mention
That it's March 3 already?
Did I mention

Finally catching a flight,
The air that smells like
Sea breeze and banana trees?
Did I mention
The goodbye
And the morning
And how they both made friends
With last night?

The Slipper Poem

Life's too short and
The tragedy of it
Never escapes me,
But strangely enough,
It's not my first waking thought
Any more than 5% of mornings.
It always hits me
In the blandest of mundane moments,
Usually standing in my kitchen
Or someone else's
And today I was thinking
If I bought a pair of slippers
To leave at your house,
Would you keep them for me?
You know, seeing as life is so short and all,
Seeing as I never want to leave,
Seeing as I always come back?
But mostly,
Because in the dissipation
Of my vaporous existence,
A pair of slippers

Is the most permanent thing
I can come up with.

CHAPTER 4-
BEATRICE

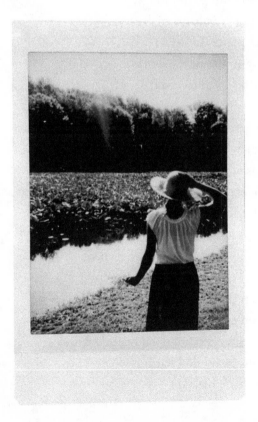

I

Her name was Beatrice.
She was born in the mountains,
Ice crystals falling from the sky,
Crystals in her jade green eyes,
Brush fire flames in her mind.
Her first glimpse of the world
Was looking up at the cold
From the floor of the ring,
Snow and stone and
All she knew was the way
The winds whipped at her petal-perfect skin,
The silent screaming matches of winter
Always out for blood over the win,
But she was a fighter.
It was in those mountains she learned
No amount of cold
Could stop the sun from shining
In between every rock and hard place,
That light always triumphed over darkness,
Broke walls faster and harder
Than wrecking balls do,

And that even in its setting,
It painted victory in the sky,
Victory over a night
That was only just beginning.
Victory over a night
That was so far from over.

II

She was raised in the desert.
She learned her place in the world
From the way the sun beat on her back
Like a thousand running horses.
She learned grit from the sand
That was always in her mouth and in her hair.
She cut her teeth on the driftwood bones
Of the ocean that the desert used to be.
She was the flower in that wasteland
Under the endless blue sky,
Thirsty for more.
She knew there was more.
There had to be more.
There was more.
There was fire,
And it scared her, but at the same time,
Something about it felt oddly familiar.
Beautiful,
When painted more revival
Than destruction.

III

She was seven when she officially met the ocean.
She'd always imagined it
A little bit more like the desert
The waves a little bit more like the wind.
Now she finally understood the concept of horizons
And she knew
That when she looked up at a clear blue sky
She was staring straight into space, but somehow,
This blew her mind even more.
The vastness of the waters swallowed her thoughts
In full, hungry gulps
(The same way she always swallowed everything about living),
And she couldn't get enough of it.
She couldn't help but wonder
What had taken her so long
To come home.

IV

⁎

Her heart was the ocean,
Beating how the waves washed the shore
In beautiful rhythm,
Some days faster and harder than others.
There was something always moving it, too,
Like the moon pulled the tide,
Like every sunset she hadn't seen yet
And everything she hadn't had a chance to love yet.
That's why the hurricane scared her.
She'd never seen that side of the sea before.
She'd heard stories of ships and sailors sinking,
And always wrote it off as their fault
For straying too far from the shore,
For not knowing how to swim,
She was never afraid of drowning,
She was afraid of her perfect reflection
In the churning waves,
Afraid that she wouldn't see it surging
Before landfall,
Afraid it would break ties
That never needed to be broken.

She was afraid because the only way
To save yourself from a storm is to run,
But she couldn't run
And leave her heart behind.

V

She escaped the hurricane to the canyons.
The canyons, she thought,
Were to the river like the desert was to the ocean,
A threadbare frame of the glory
They used to be,
Just enough to leave you hungry
For the real thing.
Walking by herself through thick nights,
She often heard the ghosts
Of the rushing waters
That used to run wild
Between stone walls.
It was probably just the wind though.
She always told herself it was just the wind
And never tried to explain why sometimes
She would lose her breath for a second,
Like the current of the river had pulled her under,
Lungs filling with water,
Sinking.

VI

She couldn't help but grow—
Beautifully like a flower,
Persistent like a weed.
She hated standing still.
Her heart was always
Ten steps ahead of her feet.
The walls of the canyon
Suffocated her more
Than they kept her safe.
There were beautiful things in the waiting,
But she wanted out more than anything
And she was a perfect example of how
The ones in the most beautiful cages
Never want out any less.
That's why she ran.

VII

⟨⟐⟩

She ran until
She found it in pieces.
Broken, splintered, shattered pieces,
But all she could see was what it could be.
It reminded her of the ocean.
Everything reminded her of the ocean,
Especially the rain,
But this carried her dream so close to reality
She could taste the saltwater in the air.
It could be argued that she
Was tiptoeing the line of insanity,
But that's what love does to one, isn't it?
I prefer to believe
She kept her hope wild and untethered,
The only way to see life
In the beaten, shrunken bones
Of a ship lying in the sand.
That's how she
Put it back together.

VIII

The sky got dark and the clouds
Hung lower and lower
Until they let loose their deluge
Of beautiful, pounding rain
And she could touch the ocean again.
She stood in the open,
Let it roll down her back
Underneath her sweet-smelling, wave-soaked dress,
Opened her eyes slow,
Smiled as she felt the weight of the water
Clinging to her eyelashes,
A hug that had been
A long time coming.
She lifted her gaze
With effortless strength towards the sky
Where light was breaking through the clouds,
Bouncing off the mirrorglass surfaces of raindrops,
Dancing on her fingertips,
Making her smile even brighter.
She felt the river come back to life
On the canyon floor,

Rushing faster than the breath
Headed back to her lungs.
This
Was her way out.

IX

She took
A broken compass
(Her heart always knew the way),
A seashell that held a recording
Of steady waves,
And a glass jar
Of yellow flowers.
She packed them quickly,
Ran barefoot into the still relentless rain,
Smiling the whole way.
She made it to the ship just in time,
Turned the corner as it lifted
Into the current.
Her feet carried her
Through a porthole,
Preparing to set sail.
She could've done it all with her eyes closed,
She'd rehearsed for this moment
A hundred hopeful times.
The wind came out of nowhere,
Whistling and soaring through the chasm,

Breathing life into her lifeless sails.
She was off.
She didn't know how long
The river lasted or where it led,
But she knew it would get her out
And that's all she wanted.

X

She didn't know how many days
She'd been on the boat,
It was home now.
She stuffed poems in every crack they would fit,
Poems written in ink for the ocean to wash away
Someday
When they made it back to the sea.
Her favorites though,
She bottled and stacked in the smuggler's hole.
The ravens brought her flowers
Every morning at sunrise.
She pressed some in her voyage log
In lieu of words
To remember where she'd been.
The rest she braided
Into her brilliant red hair
And her jade green eyes
Were so alive.
And she
Was so alive.

XI

❦

She'd watched the stars in their climb
The last few nights
The clouds had cleared,
Headed North for spring.
The winds were changing.
Her hair was blowing out behind her
Like the flag of a ship headed home.
She could feel it before
She could smell it in the air,
Sweet and clean like saltwater,
Warm like sea grass and honey.
All that day and all the next,
She kept watch.
Not for land, but for the land
To disappear.
She danced across the deck
Instead of walking.
She sang with the stars
Instead of sleeping.
She blew kisses to the sun as it set
Because every painted sky

Pushed her closer.

XII

The minute she saw it,
The same fear she felt the day she realized
That her heart was the ocean
Flew back to her side,
Clung to her heels,
Clung to her throat.
The waves sweeping the shore
Sounded almost like the song
Her heart always sang when she
Was missing home—
The one that only sounded right
Played on a grand piano
In the middle of an empty cathedral
As light filtered softly
Through stained glass windows.
That's what home felt like, too.
She should've known she'd end up here.
All rivers lead back to the ocean
Like moths to a flame,
But without the burning.
Like a bird always comes back to its cage,

But without the cage.
Like the moth and the bird
That could always spread their wings
And fly away free and alive.
She dropped anchor
at the mouth of the river.
The ocean lain out
Endless in front of her
She had been waiting for this moment forever.
Not once had she stopped
To think that being lost at sea might scare her.
She pulled her hair up,
Tied her long skirt at her knees,
And swam to shore.
Her feet landed on solid ground
And she ran.
She always ran when she was mad
Like when she had been stuck in the canyons
Except this time,
She had nowhere to hide.
She was mad at herself
For not diving straight in,
Headfirst on the biggest breath of air
Her lungs could take in.

XIII

She hadn't made it very far
Before she came head-on with the fact
That running had never done her any good.
She sat down in a field of wildflowers
And one by one,
Let go of every weight on her shoulders.
She blew them into the wind on dandelion seeds
And as she looked out across the sea,
This time,
Nothing could weigh her down.
She hoisted all the sails back into the sky,
Lifted anchor,
Let her hair down,
United her dress and let it fall,
And she leaned into the peace of the night
Not knowing what was in front of her,
Not doubting none of it was behind her.

XIV

She loved the days spent at sea,
The sun turned her skin golden like honey,
The saltwater spun her strawberry hair
Into perfectly tangled curls.
Her heart was as full as it possibly could be
With nothing in sight but the sky and the sea.
The sea that broke things,
The sea that held so much history,
The sea that carried it all home again.
There was no canary that sang danger
When a storm was coming,
But her ship never lost the strength to stand
And victory was still painted
Across the sky every night.
She didn't care how much longer
It would be until she saw land,
There was nothing she loved more
Than being lost in the endless.
Besides, her thoughts kept her company
And when they didn't,
She wasn't afraid of being lonely.

XV

Nothing good seems to last
Longer than a breath
Can be held.
Longer than birds
Stay caged when they
Can smell the sky,
Longer than hands
Can hold knots
That don't want to stay tied
And her perfect
Was no exception.
The skeleton ship that came back to life
Wasn't eternal.
Three months into deep waters,
It sprung a leak and now
Instead of wishing the shoreline away,
Wishing *safe* away,
Beatrice swept the horizon for land
Instead of sleeping.
She was drowning already
And the water

Had yet to hold her.

XVI

The minute the waves broke
Into rocks and sand,
She abandoned ship—
Left everything she loved and
The sea fought hard for hours
As she swam to shore.
The dolphins never once
Left her side
But she didn't know that.
Not then, at least.
She didn't know what else to do,
So she started running again.
She was caged
Instead of free again.
She left home
Before her feet
Ever touched the ground,
Crushed her heart into the ground,
Pillar of salt
Turning around.

XVII

She left it all behind.
She didn't say goodbye
To the ocean,
Didn't want
To look behind her.
In front of her, at least,
She didn't know what there was to be afraid of.
Somehow that was safer.
She ran back to the mountains,
Back to where
Every cage first found her.
They hadn't changed.
She had.
She'd gone from fearful
To fearless,
And then back again.
The sky screamed victory
Just the same,
But she never remembered to look up.
All this running
Got her nowhere,

Got her back to where
Grace will send her off
Into the unknown
All over again.

The Beatrice Drafts

The Girl from the Ocean

She woke up thinking about the ocean again,
The days she used to spend
In her white dress made
Of sun-bleached sailboat sails,
Hair in perfectly tangled saltwater curls,
Feet as rough as the ropes she scaled.
Her heart was fuller back then,
With nothing in sight
But the sky and the sea
And oh the sunsets she'd seen out there..
That's when she decided
She was tired of being caged
And hated that she'd decided
To settle down.
That's also when she promised herself
She'd go back.

The Girl from the Meadow

She sat
In solitary silence
On the snow-covered skeletons
Of barn wood floorboards
Shivering as the freezing wind blew in
Through the open door
Silver braid falling down her back,
She remembered
When she was the fiery redhead girl
Who spent her days in the meadow
Breathing nothing but warm wildflower breeze.
Her jade green eyes
Were brighter back then
When they could reflect the vivid grass
Instead of the snow.
A tear froze halfway down her pale cheek
As she remembered
When they used to always be
Kissed by the sun,

And she promised herself
She'd go back.

The Girl from the City

She sipped her coffee alone that morning
Again.
With a sad smile she remembered
The days when she used to be
The pretty girl no one knew
Sitting in the corner on a New York subway
Sipping her coffee every morning
In the middle of the city,
Tortoise shell glasses
Framing her crystal-cut eyes,
Wavy hair tied up
In a smart messy bun
Pretending she was headed
To her inconspicuous office job
Just like everyone else.
She'd loved the city,
She still thought about it every day
And every day she promised herself
She'd go back.

The Girl from the Woods

SHe would never forget that color of blue—
The color the sky was
The day she heard the church bells
From where she was standing
In the middle of the woods
Just outside the front door
Of her little yellow house,
The one built of sad songs
And memories
And broken butterfly wings
Next to the lake that always hung
Under a layer of fog like a magnet.
It was lonely, but she'd loved it.
She'd loved the busy quiet
Of the bluebirds in the redwood trees
And the inescapable silence
Every time her head got stuck
In one of the clouds that fell to the ground.
She'd often asked herself how
She'd left a place where her heart
Felt so at home.

Now all she could do
Was hope her restless heart
Would take her back through those woods someday.

The Girl from the Beach

She bleached her red hair blonde that summer
So it would blend in chromatically
Somewhere between the sand
That softly clothed the shore
And the white foam that pulled
The sapphire blue waves in
From the deep,
Waves like those of the tropical sea breeze
That filled her lungs
And made her soul sing
In melodies played
On weathered ukuleles,
Ringing all the wind chimes
Hanging from her heartstrings
As she surfed on waves of sunshine.
She asked herself, yet again,
Why she'd ever left
And she remembered how
She'd always promised she'd be back,
She still hoped it would be true.

The Girl from the West

That's where she learned
To drive like a runaway—
In the country that belonged to the sky
Where all the small towns
From the storybooks had gone
With their cornfields and cattle herds
That never ended.
Where the air smelled like dust and honey,
Where she could chase a sunset forever
And never get any closer.
It drove her insane all the same because
Driving forever and getting somewhere
Are two very different things.
She knew that better than anyone.
She took a plane off a dirt runway
In the middle of the night
And she didn't look back
Until it was too late.
Now she never stops wishing
She hadn't tried so hard to get out.

The Girl from the Mountains

She holds onto her memories of the mountains
The way the ice held onto the trees,
Like the thin twigs at the ends of the branches
Were their only lifelines.
Up there, the light in her eyes
Made the sun look black.
Her hands were strong from climbing,
Her legs were strong from racing the daylight
Time and time again.
And on her head was always
A crown of flowers
That were only supposed to bloom in spring.
She left them everywhere she went
So she would never be too hard to find.
She doesn't even have a garden anymore.
The light in her eyes
Is decaying like a dying star
And she knows it.
She knows what happens to dying stars.

The Girl from the Desert

She still misses the desert.
She misses climbing the dunes every night
To watch the sun set and the stars fall.
She misses running
Down the dunes in the dark,
Barely keeping up with her legs.
She misses the silence
That matched her heart perfectly.
She misses the way
It made water feel
On her lips and her tongue.
She misses the endlessness of everything,
The time she had for reminiscing.
She doesn't smile anymore
When she goes through the photographs
And letters from her better days.
Remembering doesn't feel good anymore.

The Girl from the Volcano

And when she lived on the volcano,
She burned bridges recklessly.
Her skirt of flames
Never scarred her legs.
She ran on coals
And her feet never charred.
She breathed the oxygen
Right out of the smoke.
Her hair burned red
Against the hazy sky,
And she flew
Out from underneath the ashes
Like a phoenix.
But like a phoenix,
She couldn't stay put.
She moved on, and now
She misses her fiery skirt
And fiery hair,
She misses the smell
Of the smoke in the air...

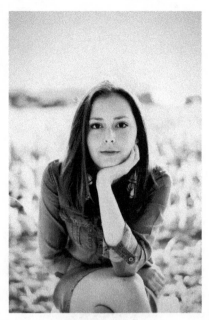

Photo by Jaimi Vore

Megan Kirkpatrick is a poet and author residing in the northeastern United States with her wonderful family. Megan loves nostalgia, music, all things vintage, salad, sunsets, road trips, avocado toast, coffee, late nights, green smoothies, daisies, grammar jokes, hugs, airports, and of course, Jesus. When she isn't writing, Megan is either snuggling puppies, completing school assignments with a concerning amount of enthusiasm, or off on another adventure with her favorite people. She is wholeheartedly looking forward to a life of learning lessons, growing old, and writing poems along the way to remember every last bit of it. She can be found on Instagram at @meganmadewords or contacted via email-writer.megan.kirk@gmail.com.

I'm Still Stuck on That Ski Lift in New York

Yellow (Vol. I)

Yellow (Vol. I)

Juniper

A Confession

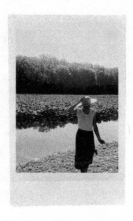

Beatrice

CPSIA information can be obtained
at www.ICGtesting.com
Printed in the USA
BVHW081714150721
612041BV00003B/180